MY WHITE FRIENDS

MY WHITE FRIENDS

MYRA GREENE

KEHRER

For Audraine, Adrianne, and Ayola

The women who taught me strength, determination, and friendship.

JV, Chili, New York (2009)

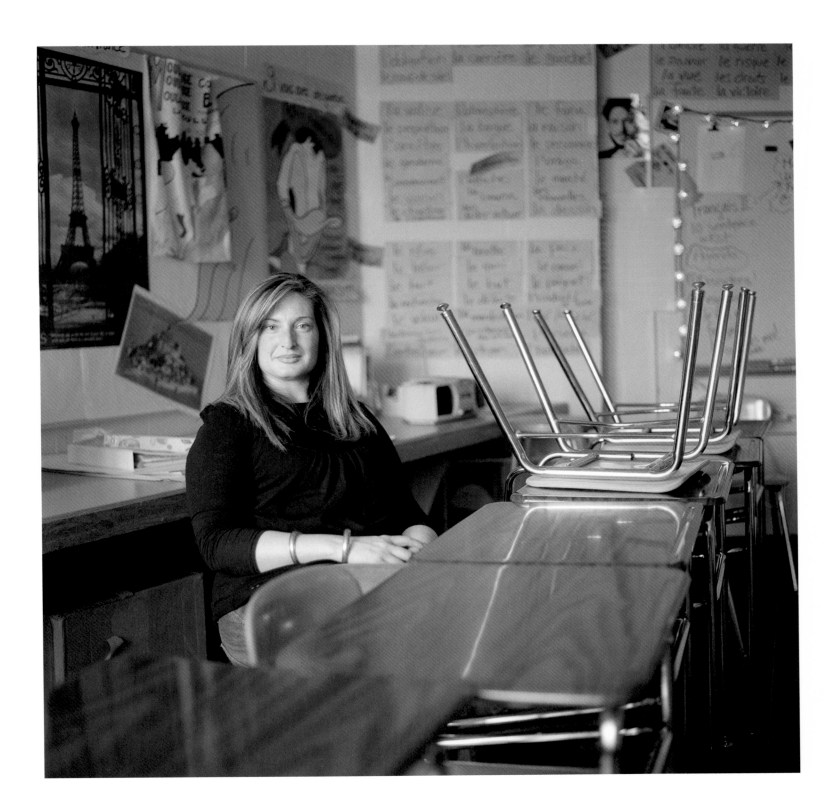

DF, Belfast, Maine (2008)

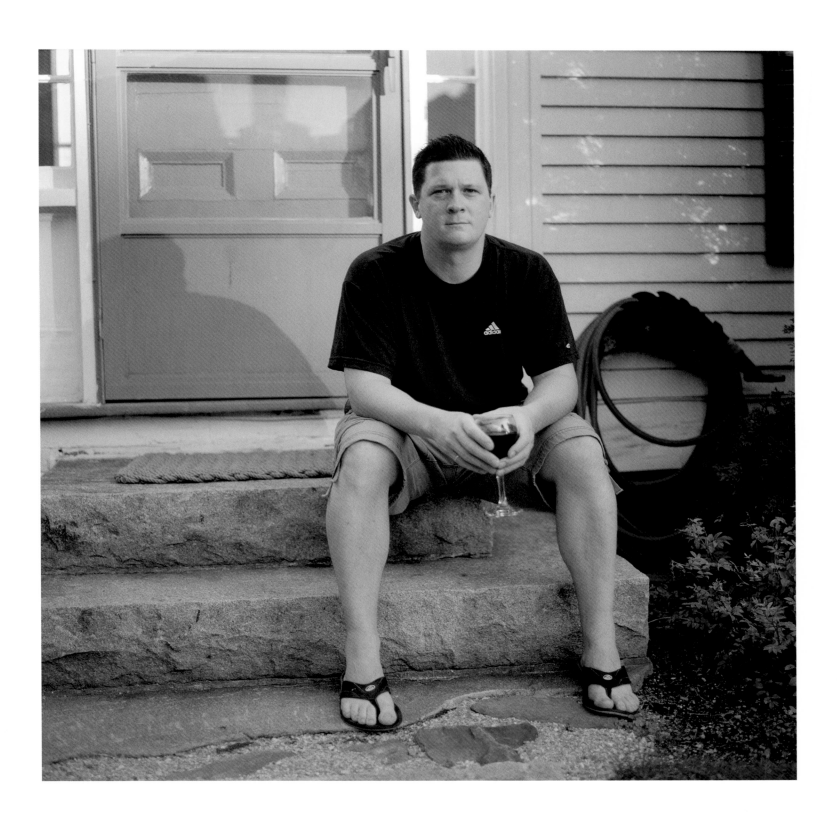

TZ, Los Angeles, California (2008)

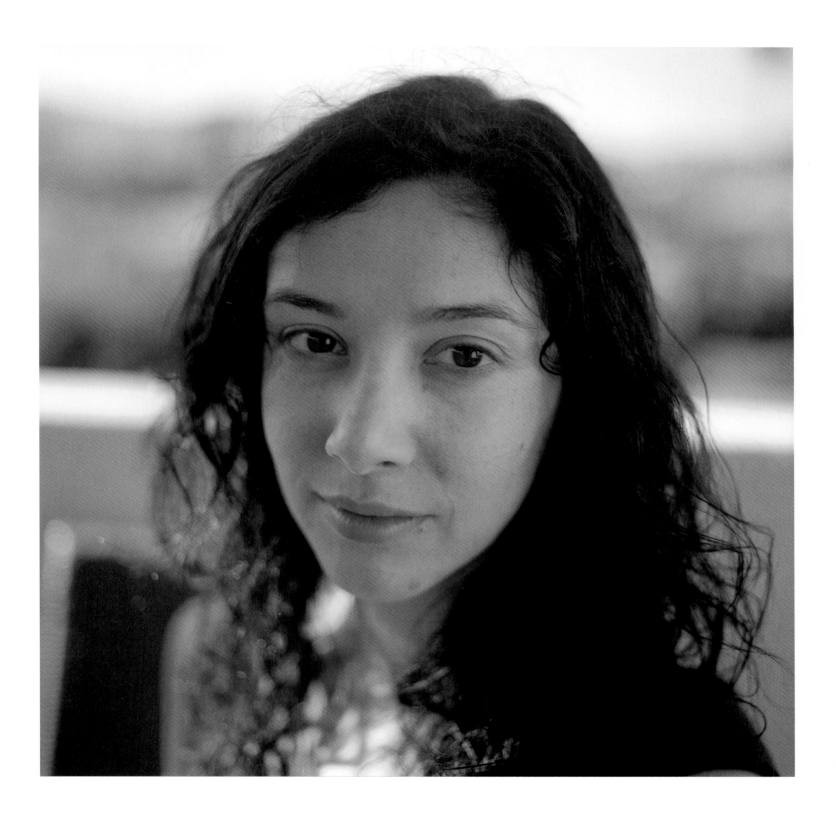

SD, Lake George, New York (2009)

MM, New York, New York (2011)

JS, New York, New York (2008)

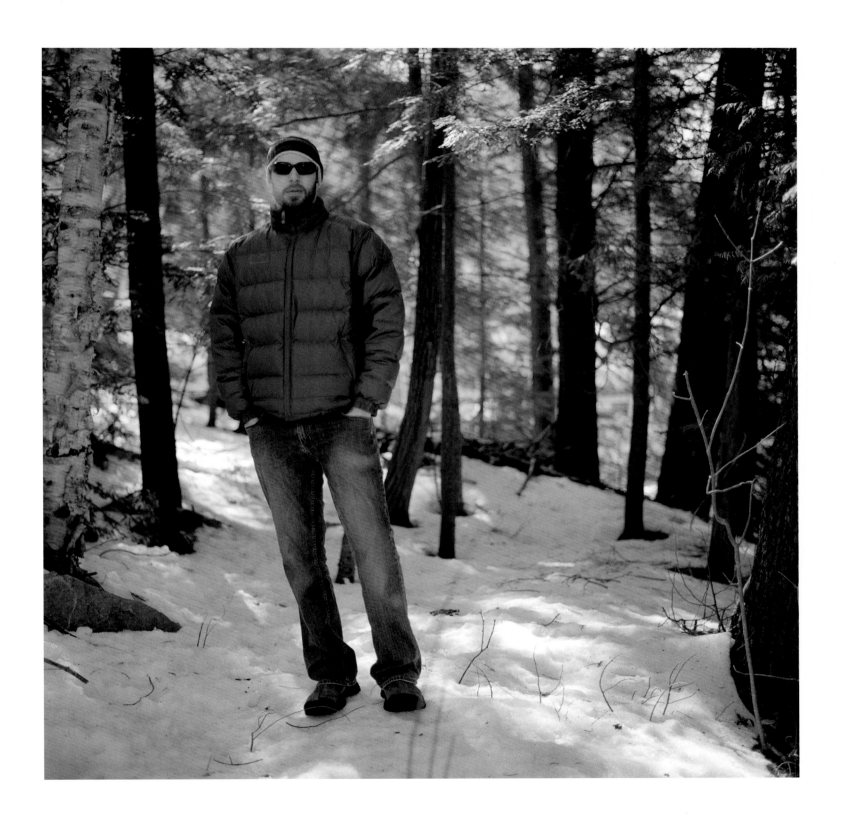

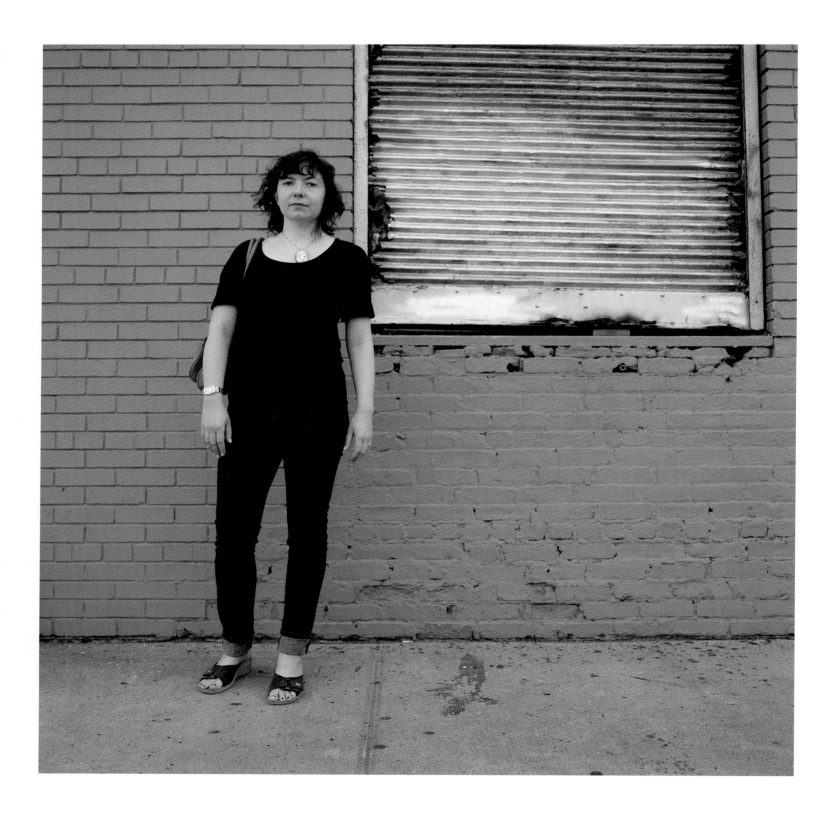

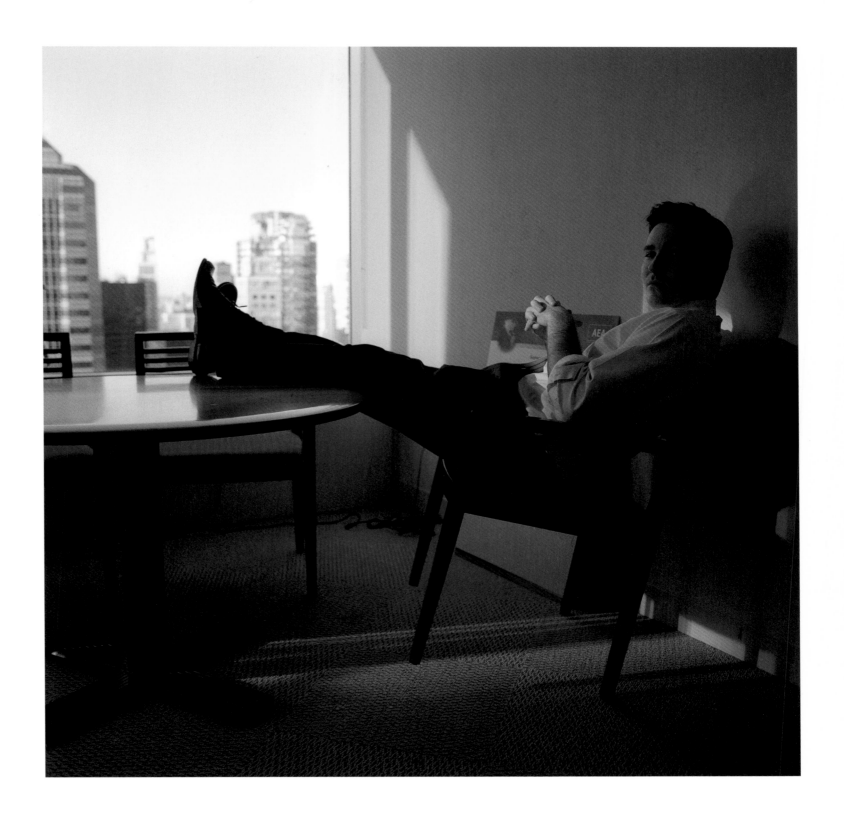

RD, Rochester, New York (2009)

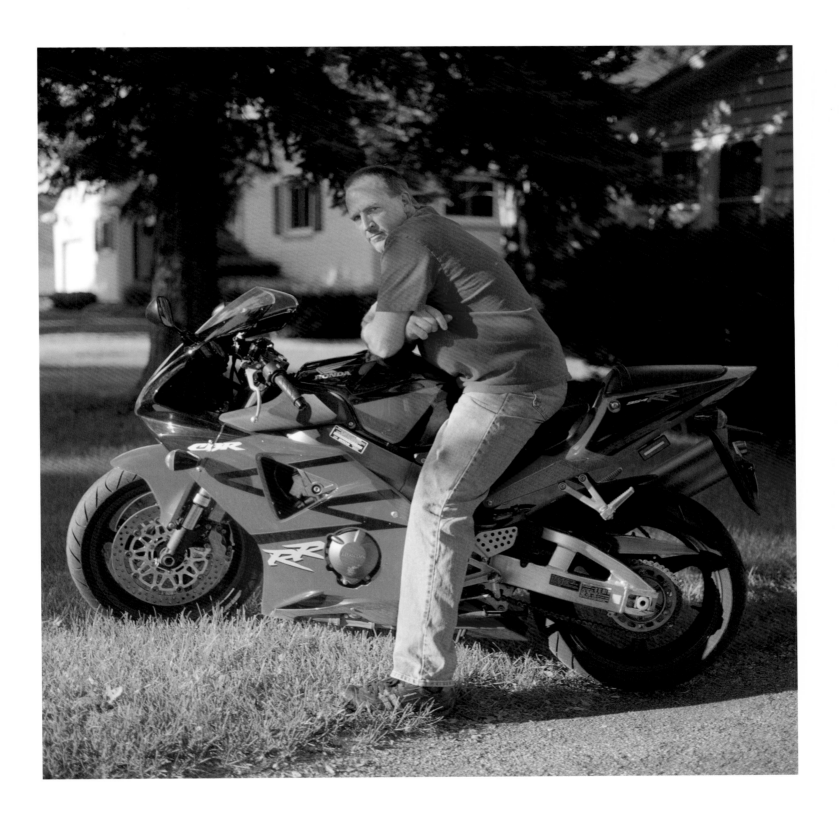

AL, Rochester, New York (2009)

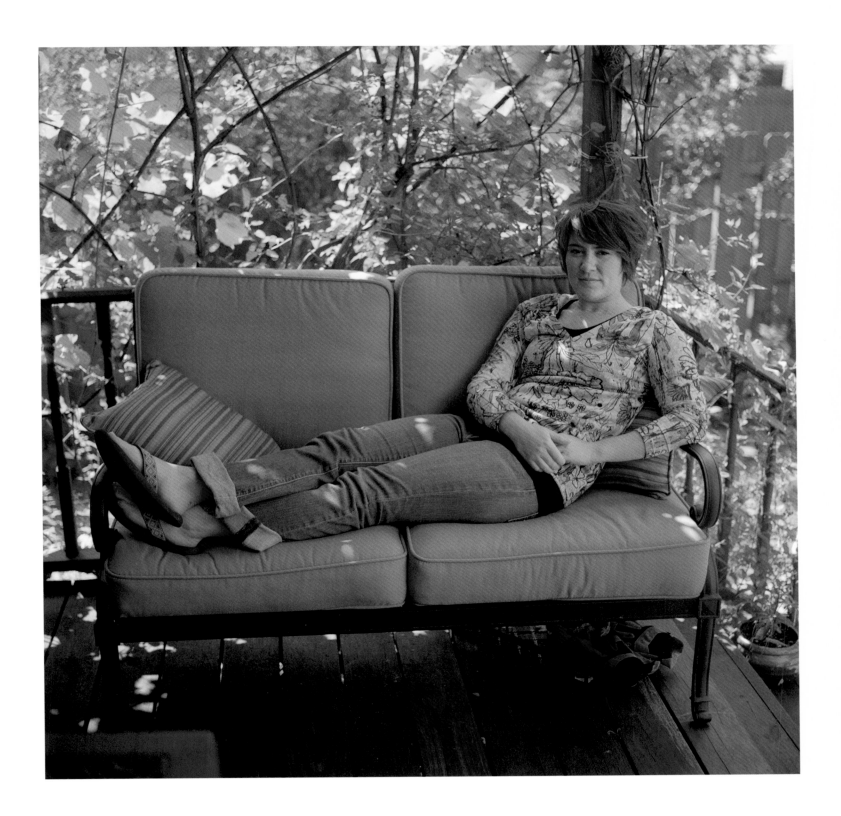

JG, Brooklyn, New York (2009)

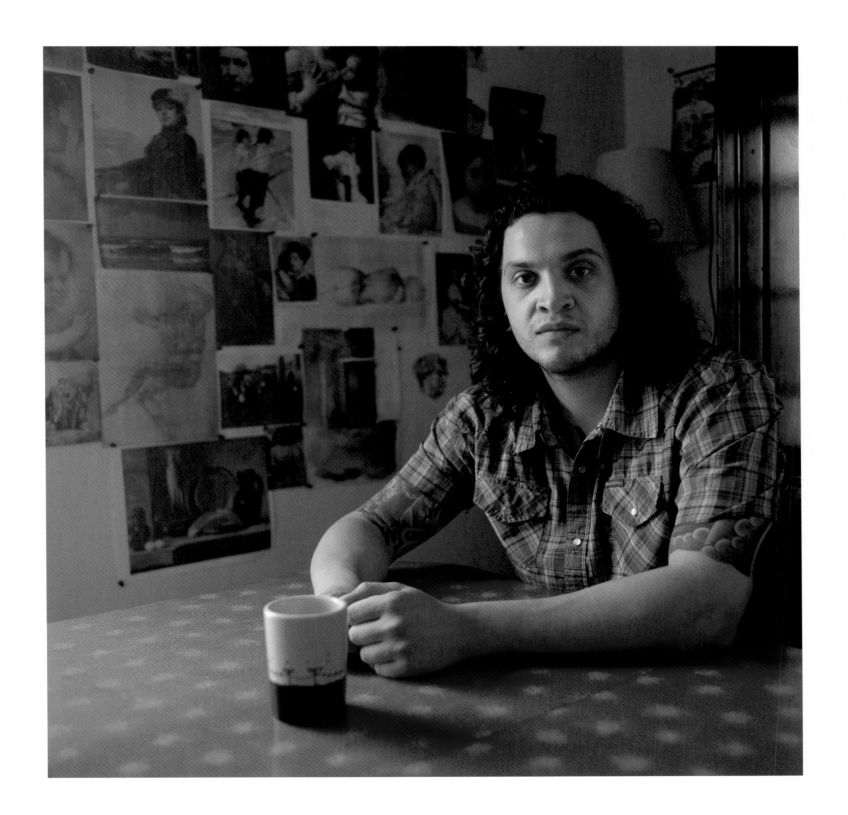

TP, New York, New York (2009)

CS, Walworth, New York (2011)

DL, Rochester, New York (2008)

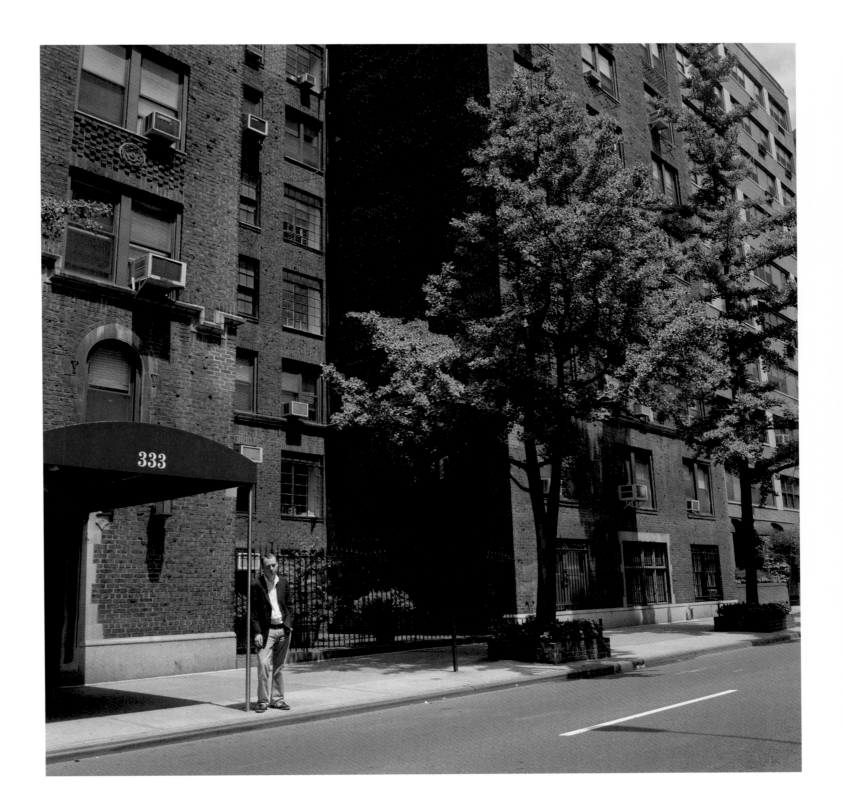

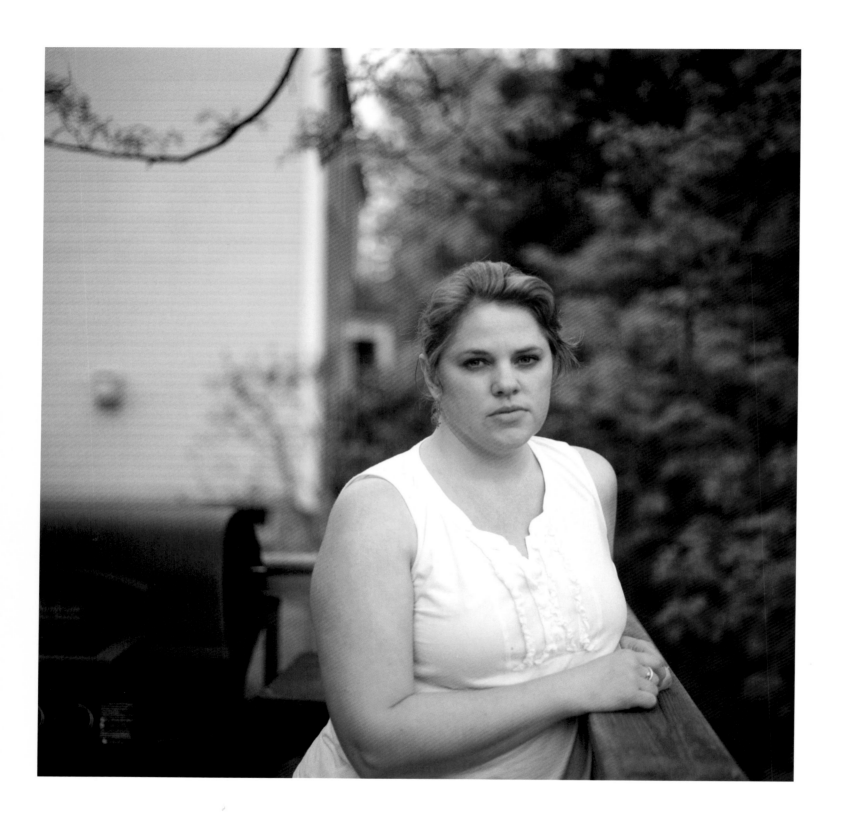

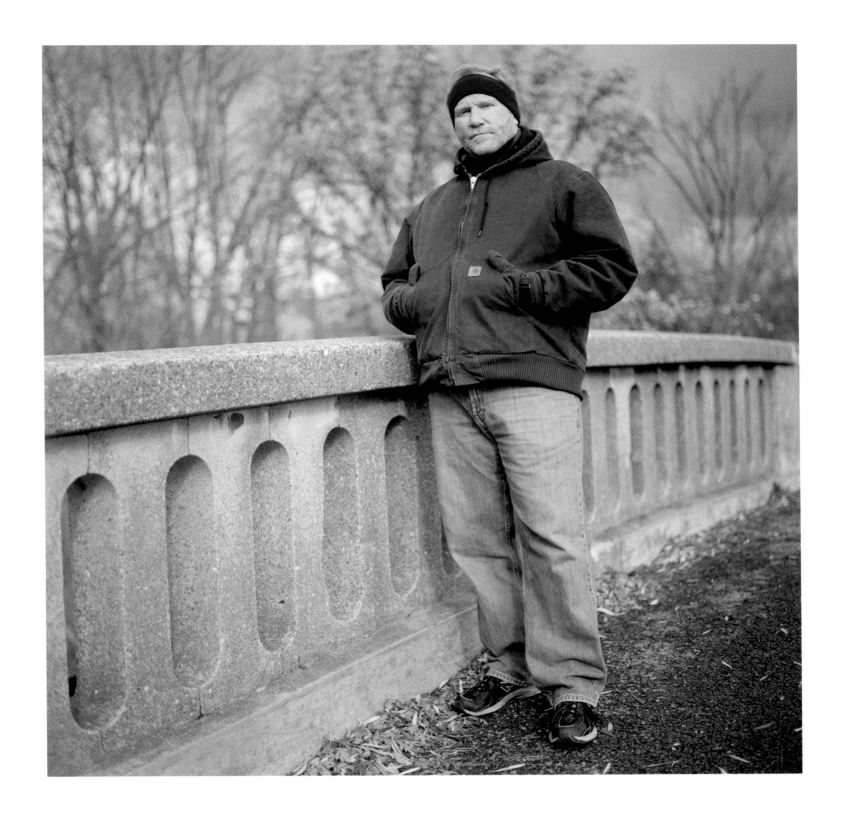

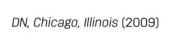

DN, Chicago, Illinois (2009)

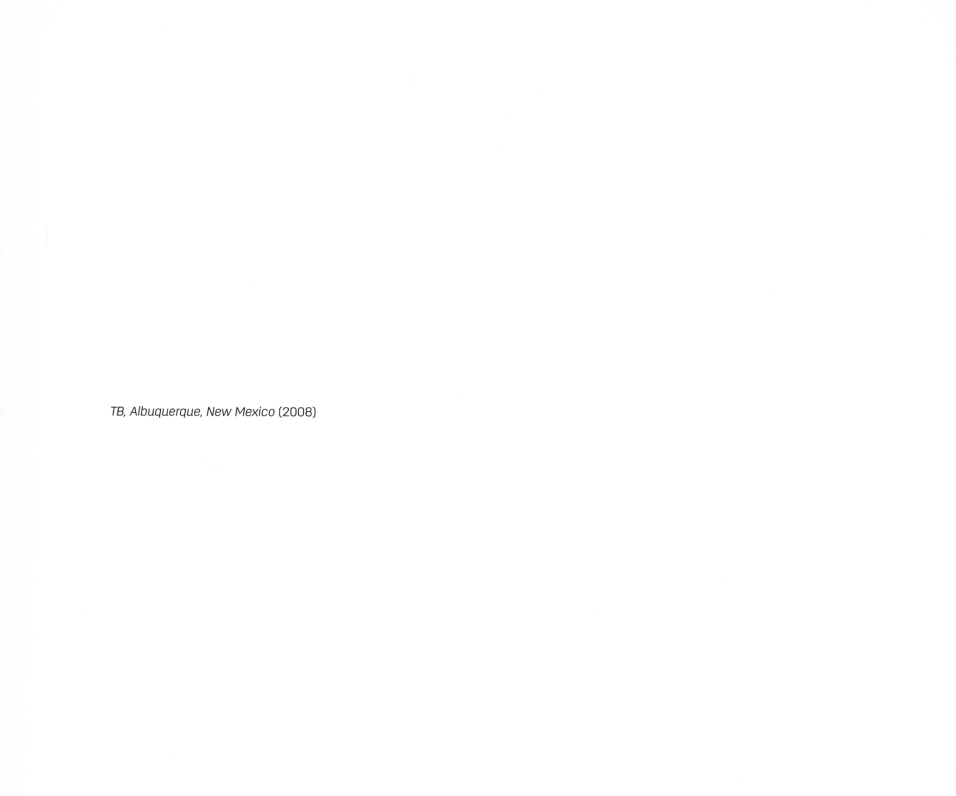

TB, Albuquerque, New Mexico (2008)

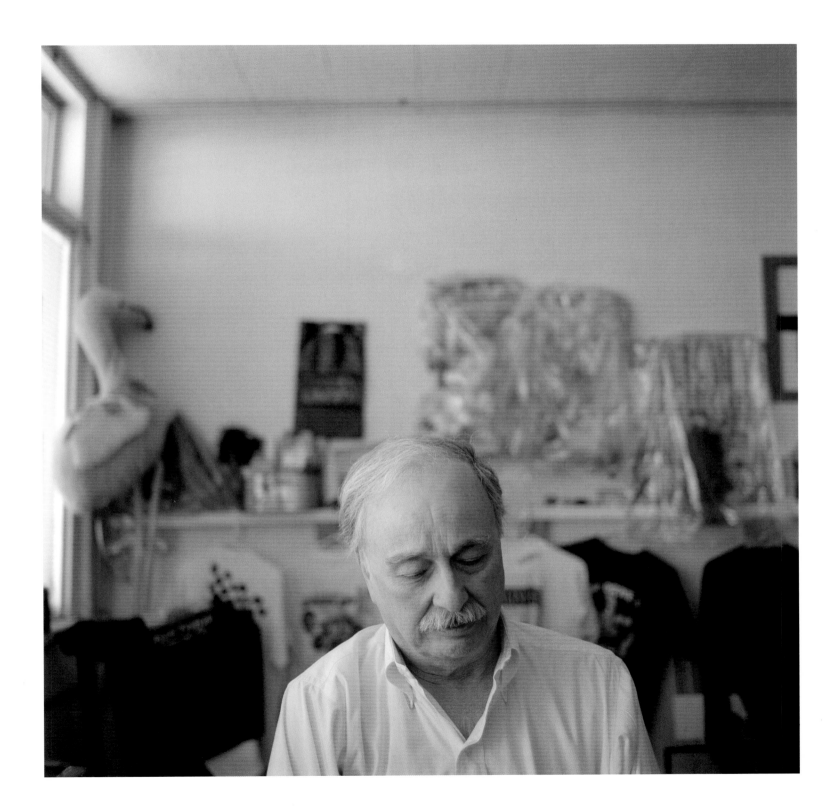

ZT, Rochester, New York (2007)

JFG, Brooklyn, New York (2009)

EG, Brooklyn, New York (2010)

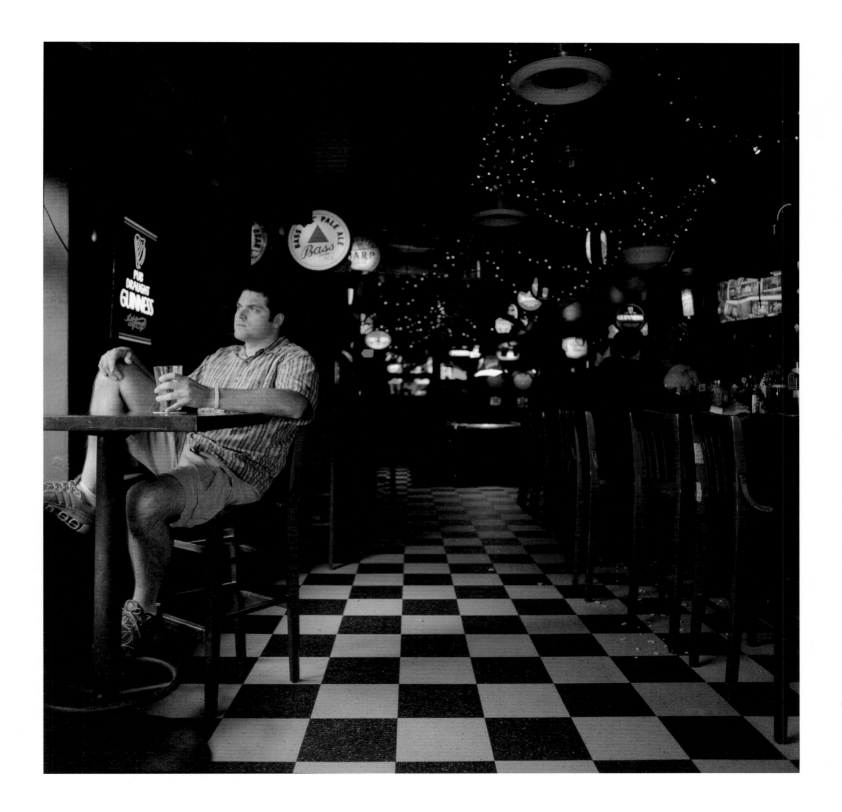

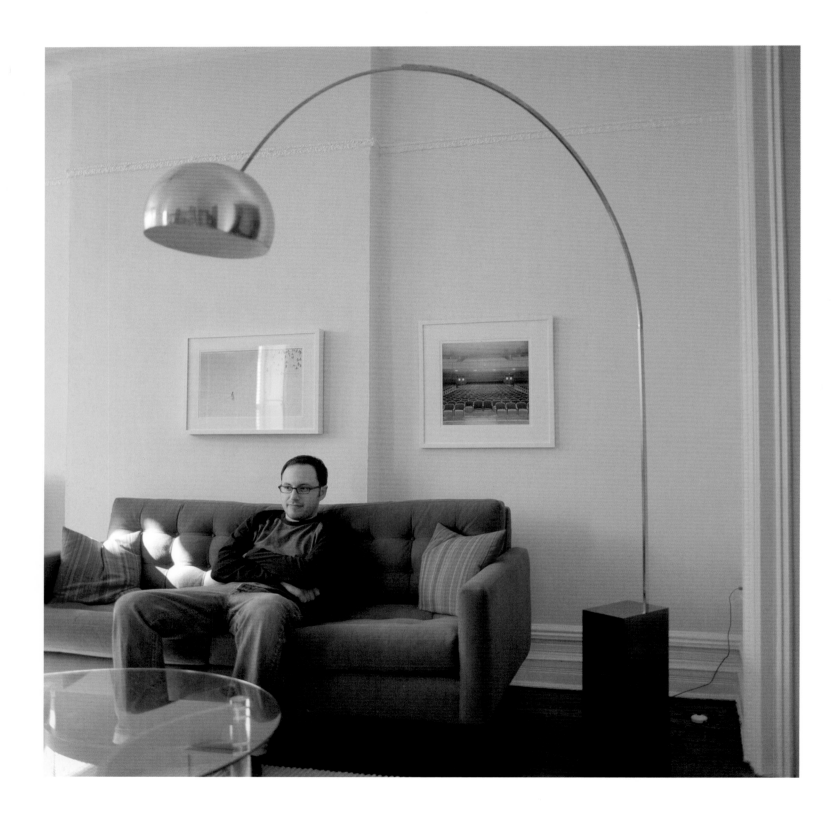

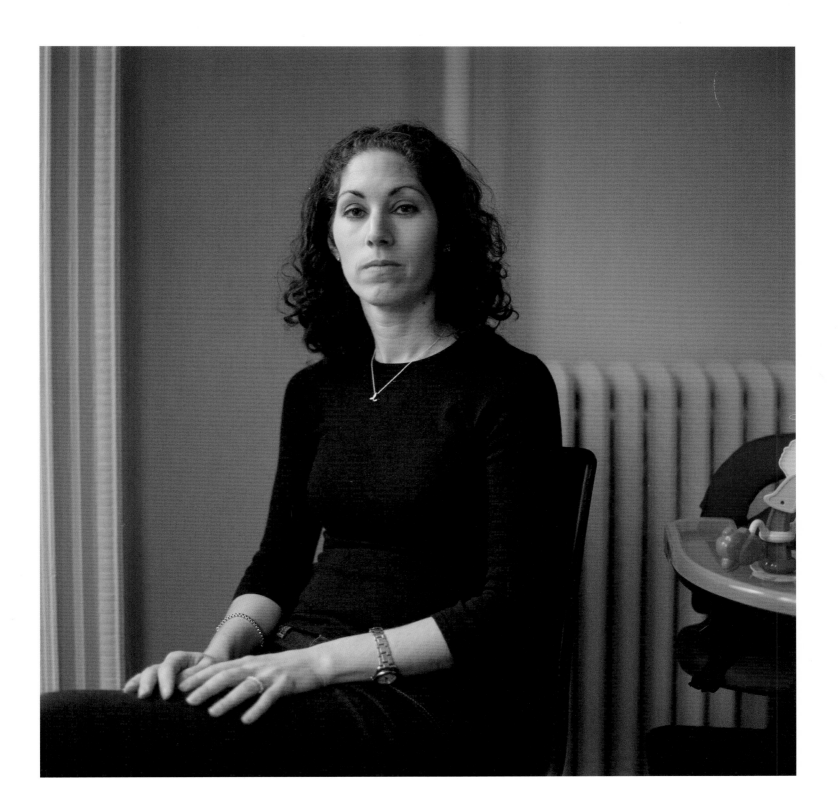

LF, New York, New York (2009)

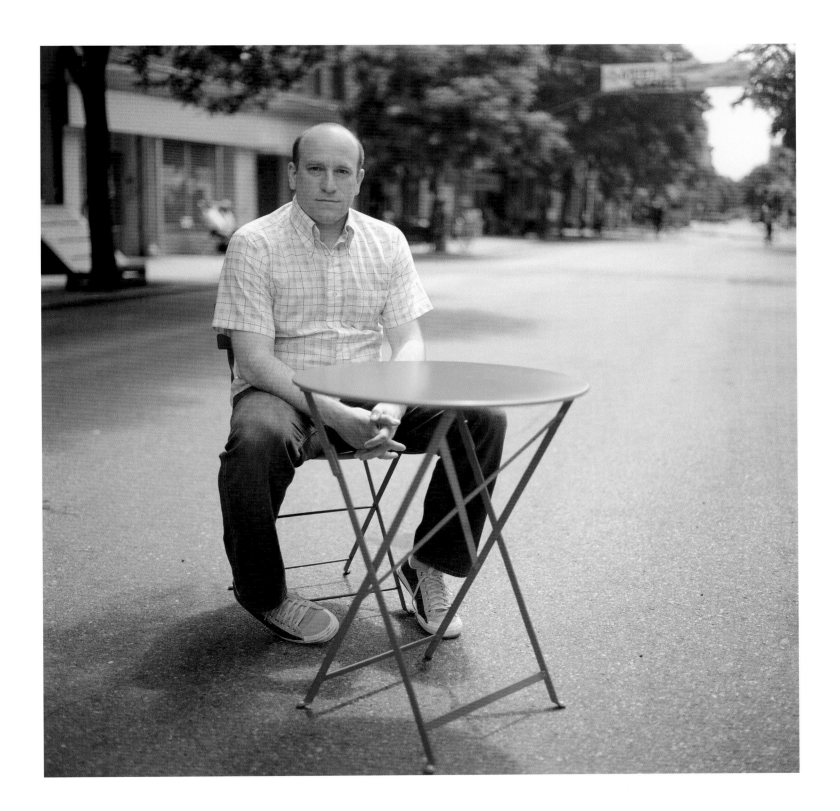

JM, New York, New York (2010)

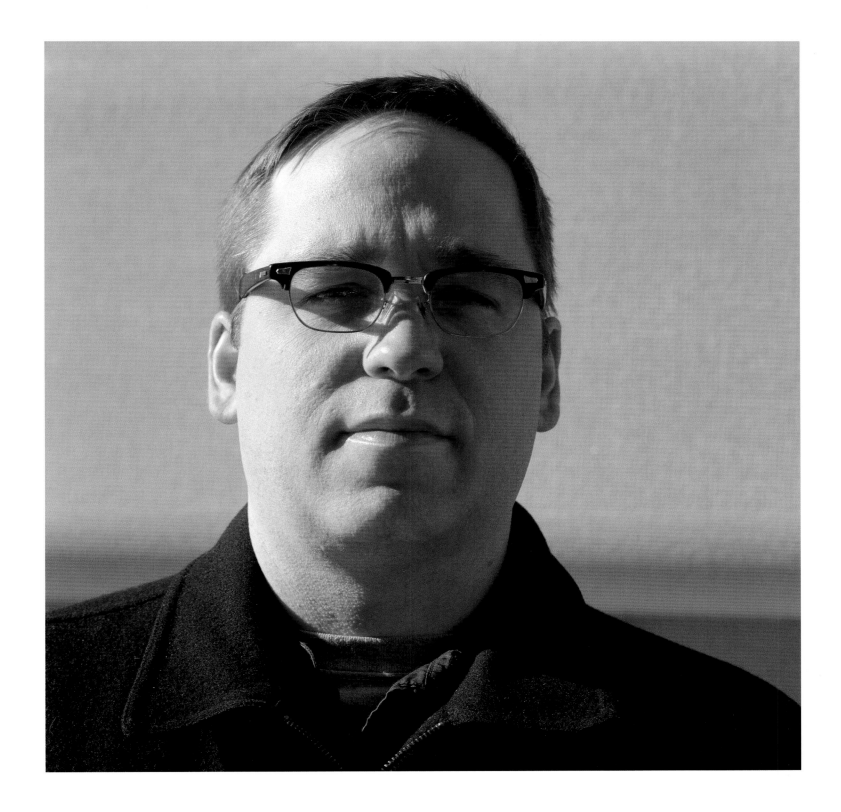

KR, Columbia, South Carolina (2011)

RL, Livermore, California (2008)

The Ws, Chicago, Illinois (2008)

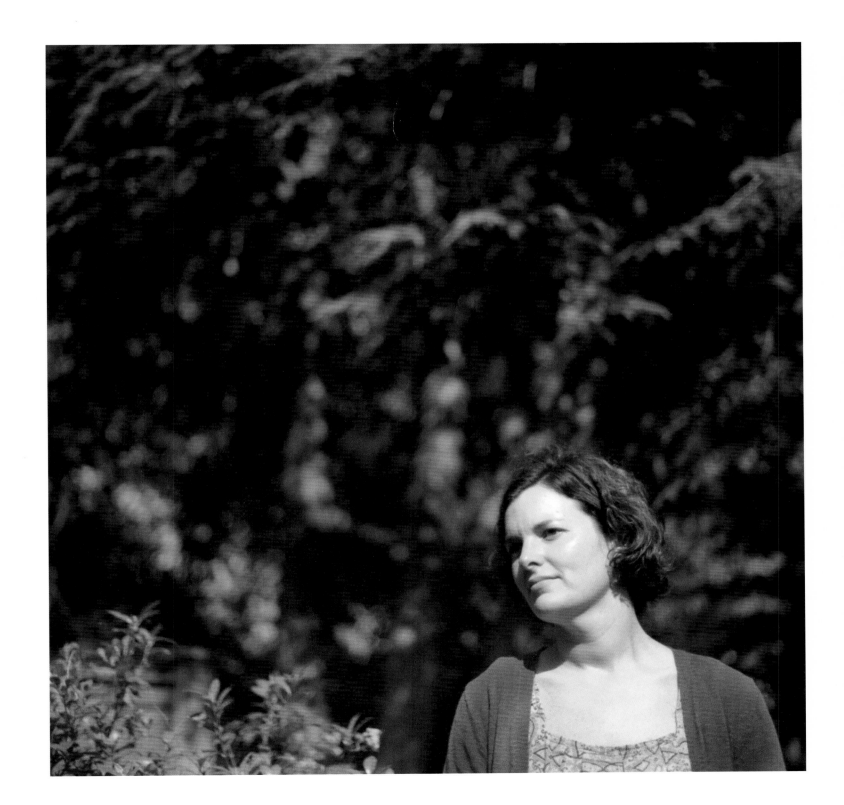

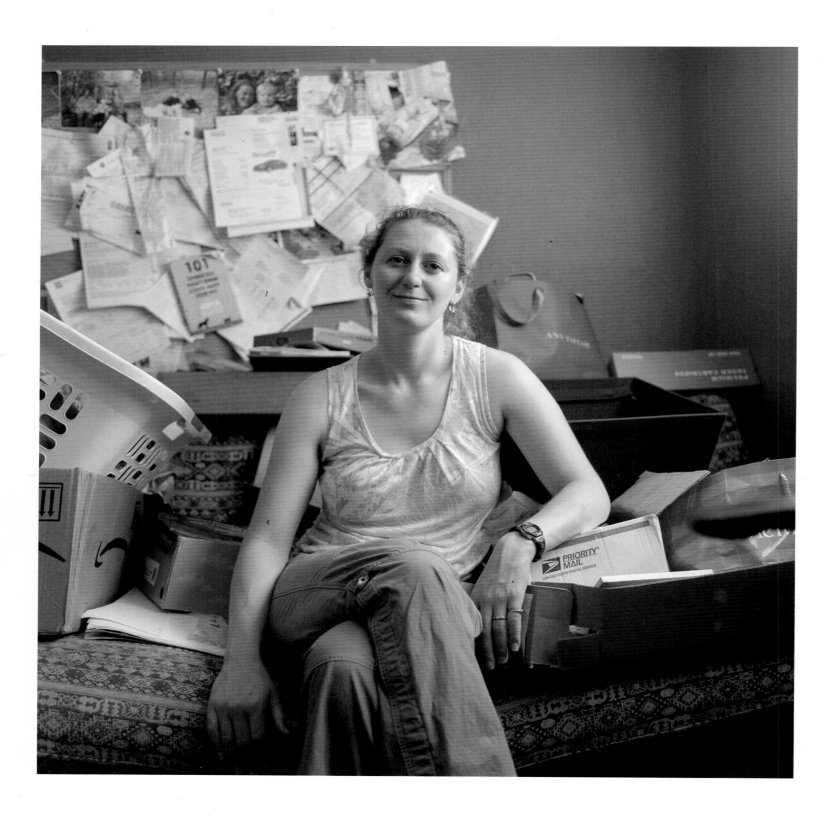

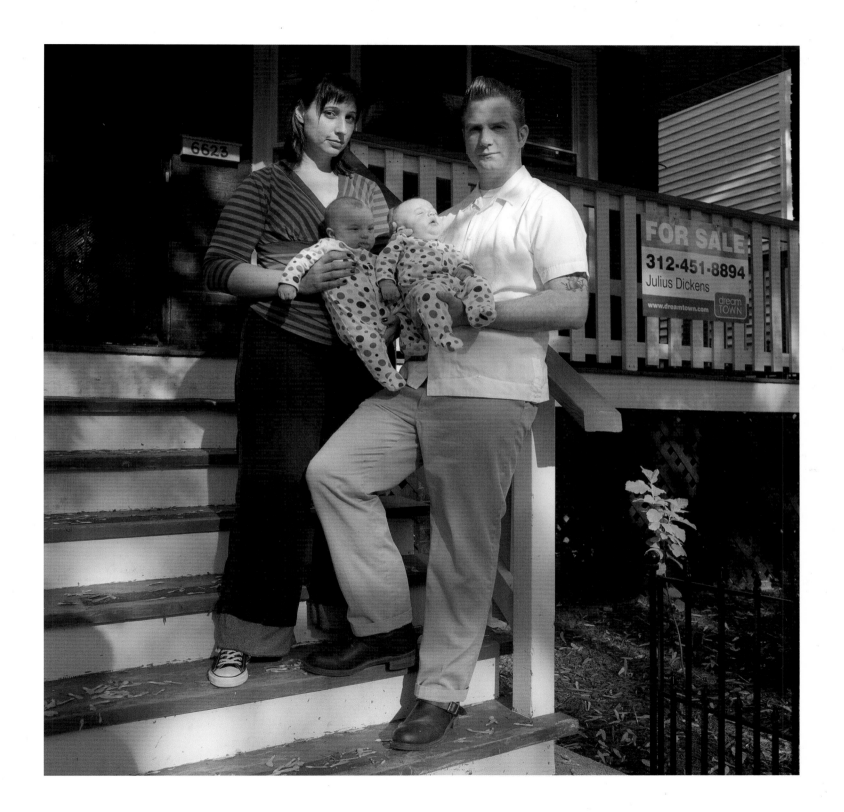

HD, New York, New York (2008)

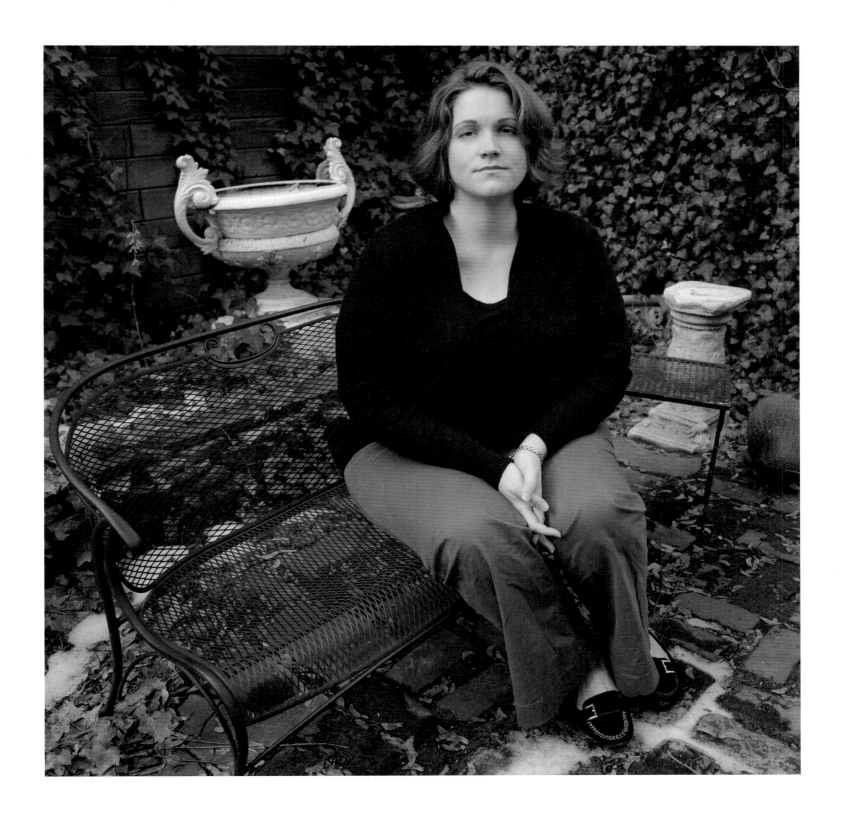

MG, Chicago, Illinois (2009)

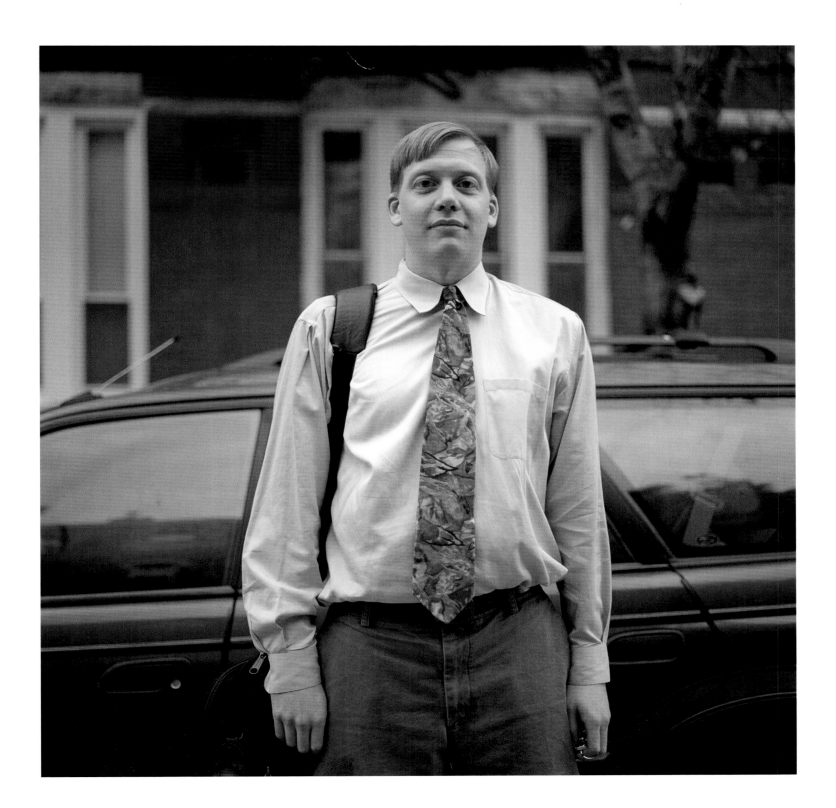

KB, Chicago, Illinois (2011)

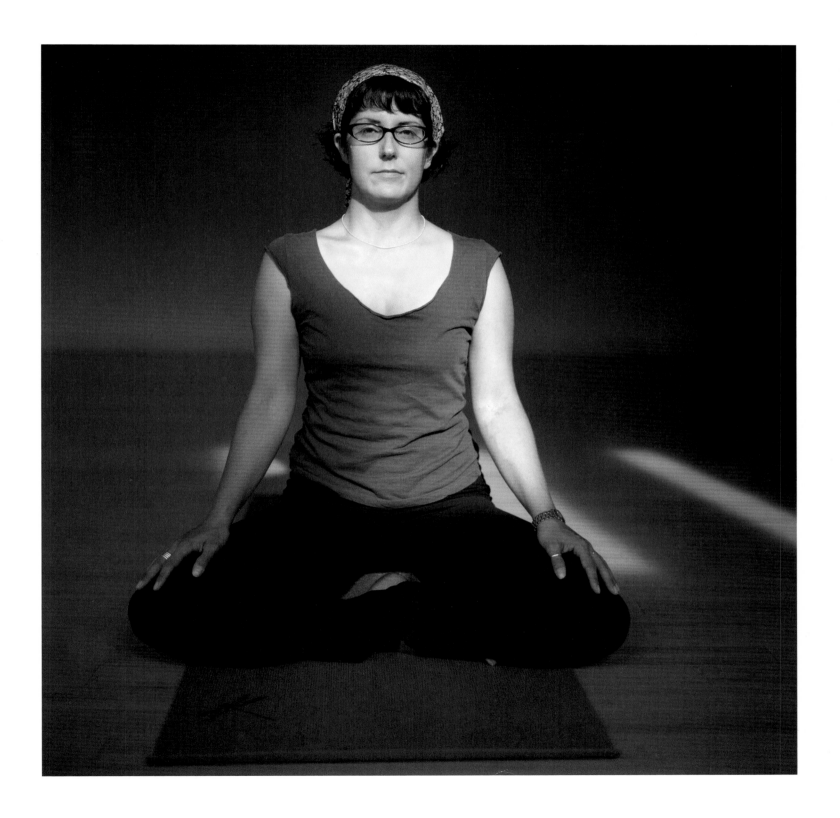

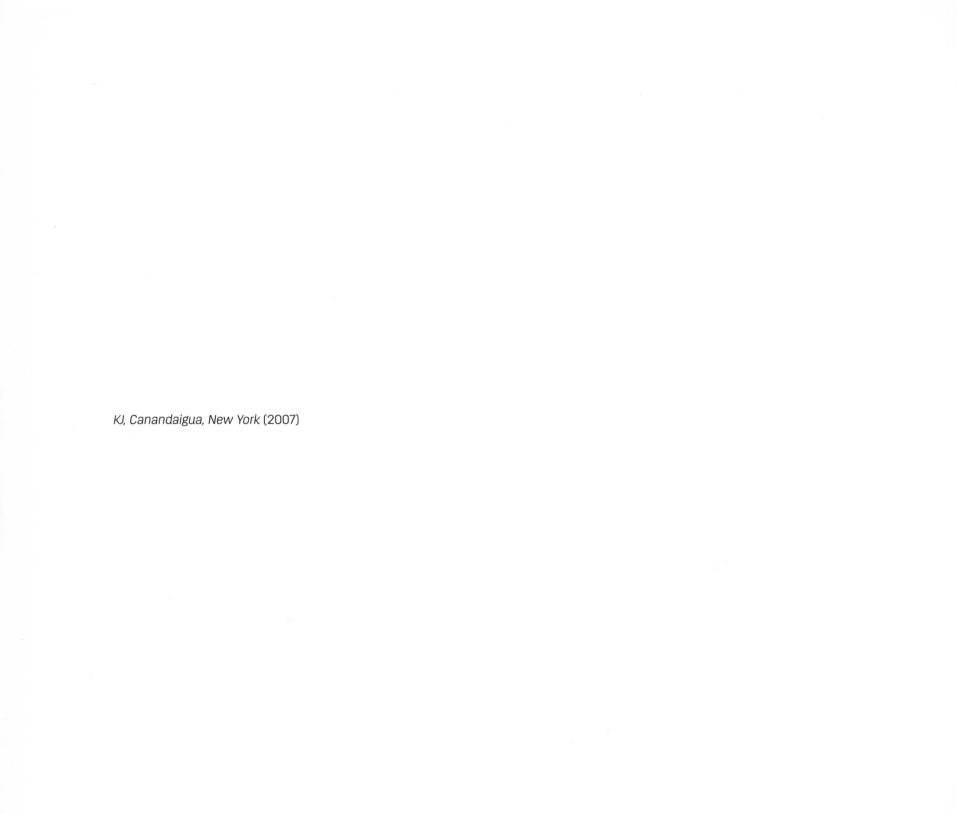

KJ, Canandaigua, New York (2007)

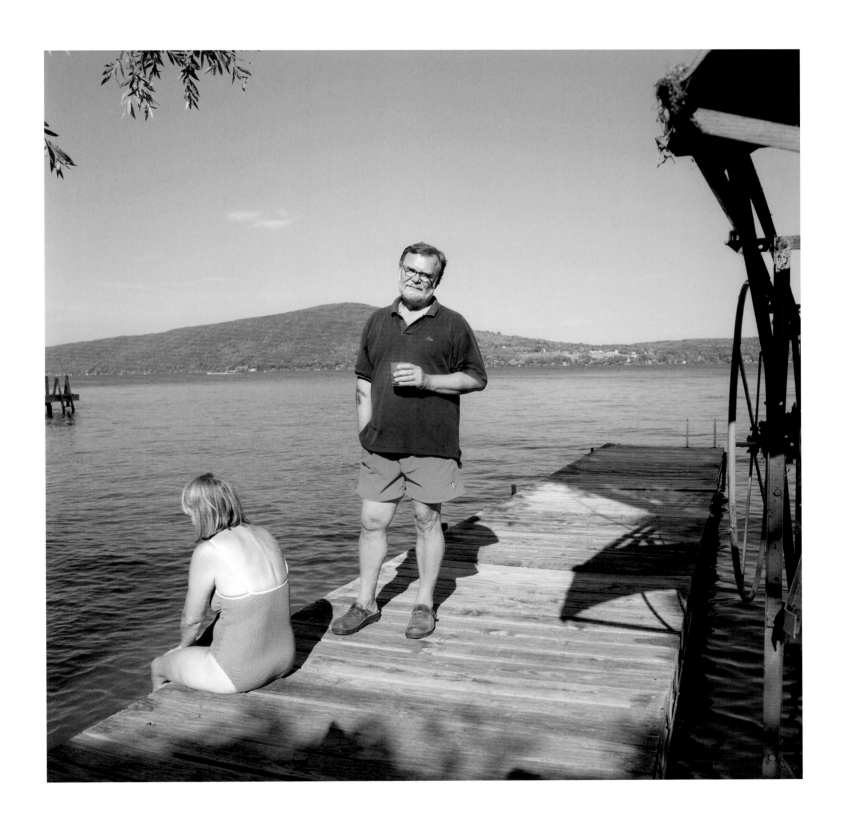

JE, Chicago, Illinois (2008)

JKB, Rochester, New York (2008)

JPM, Los Angeles, California (2008)

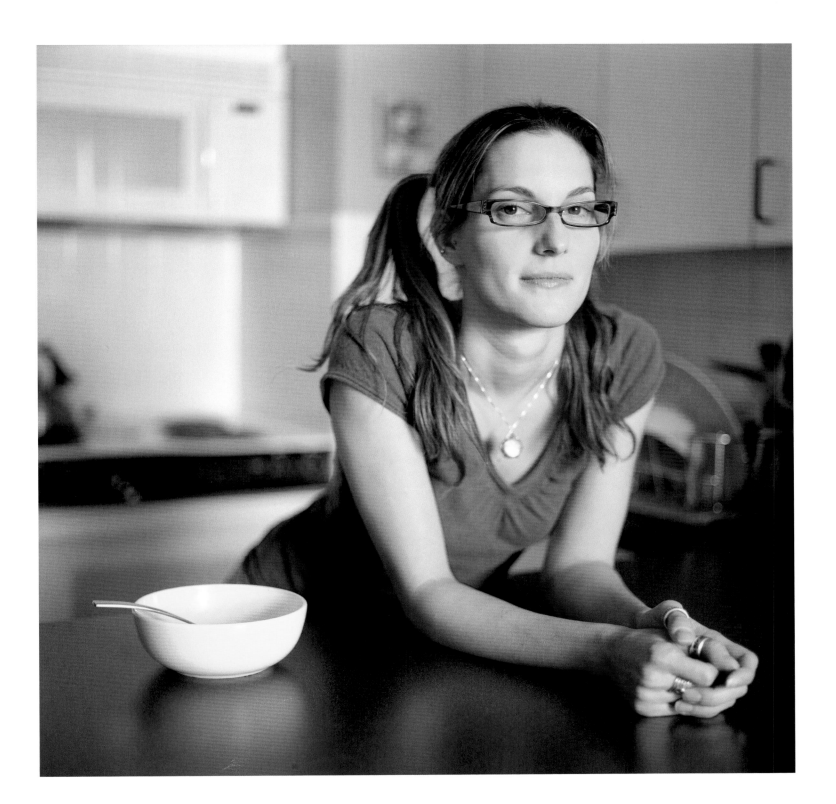

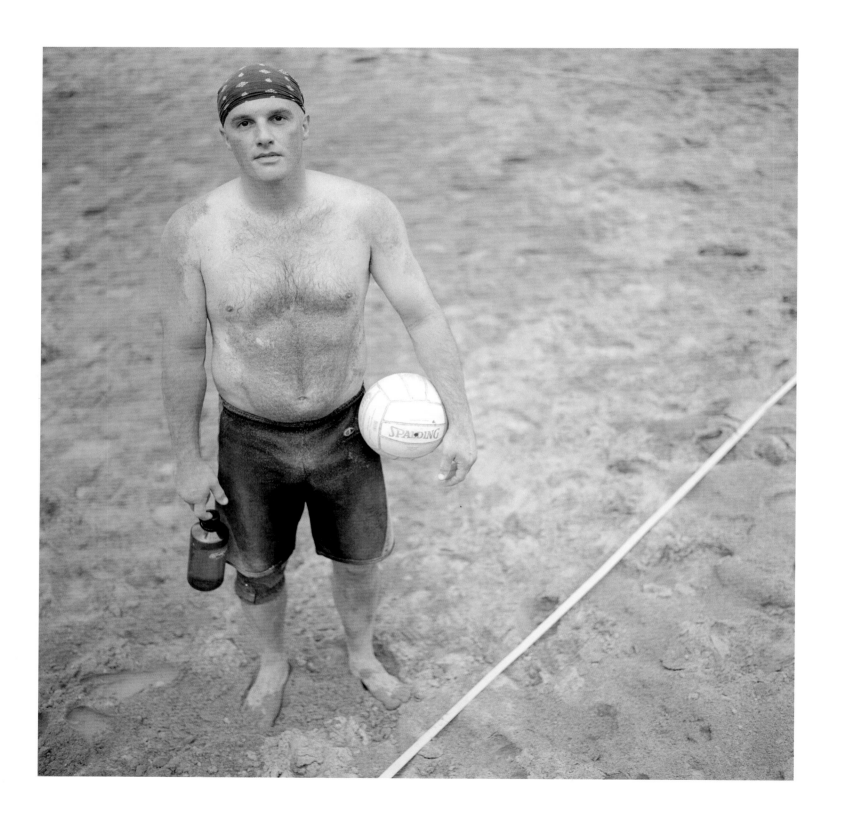

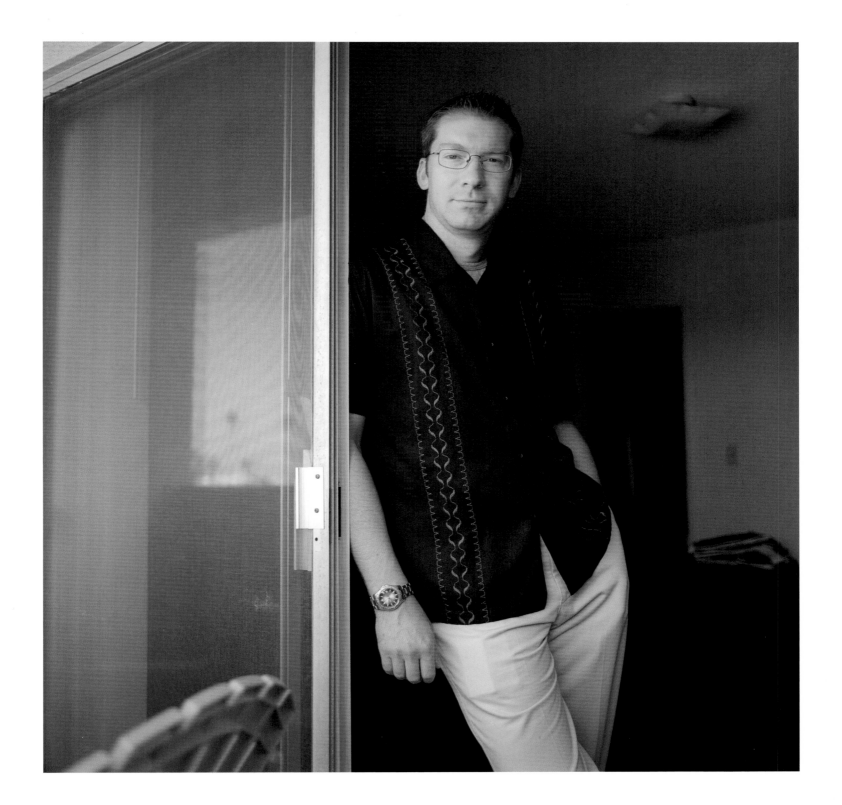

AG, Rochester, New York (2007)

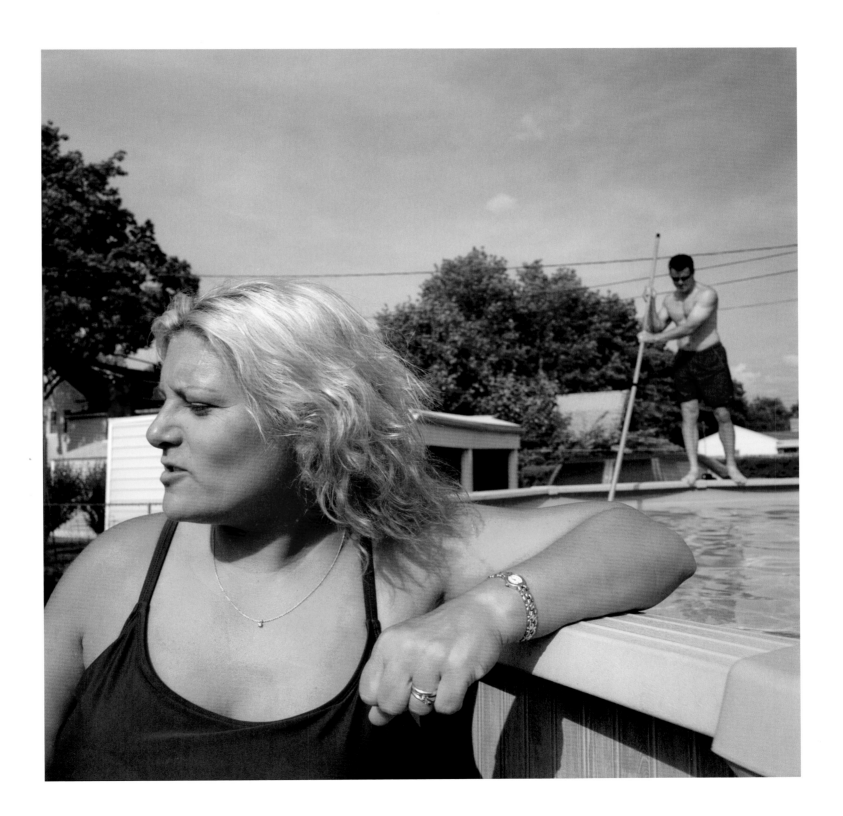

SS, San Francisco, California (2008)

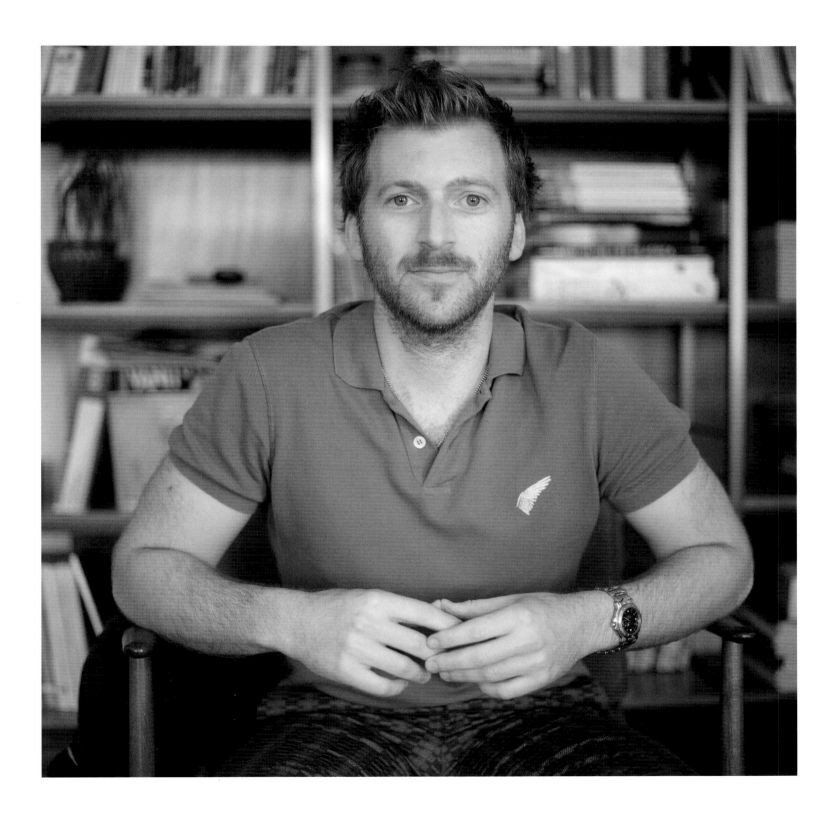

JR, Bellefonte, Pennsylvania (2012)

DW, Rochester, New York (2007)

KM, Rochester, New York (2009)

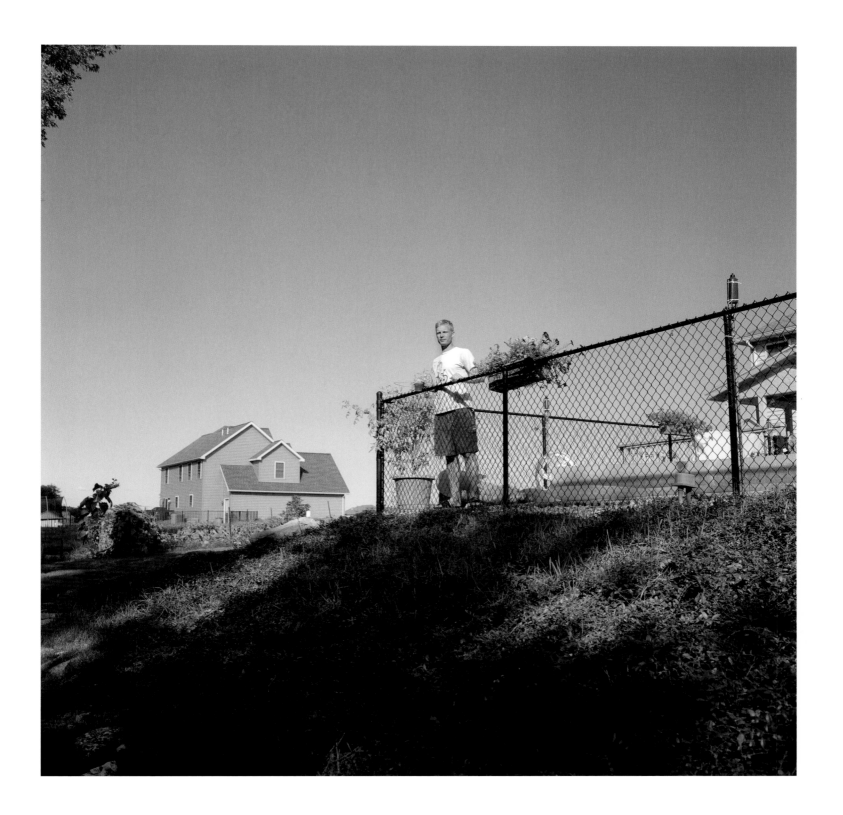

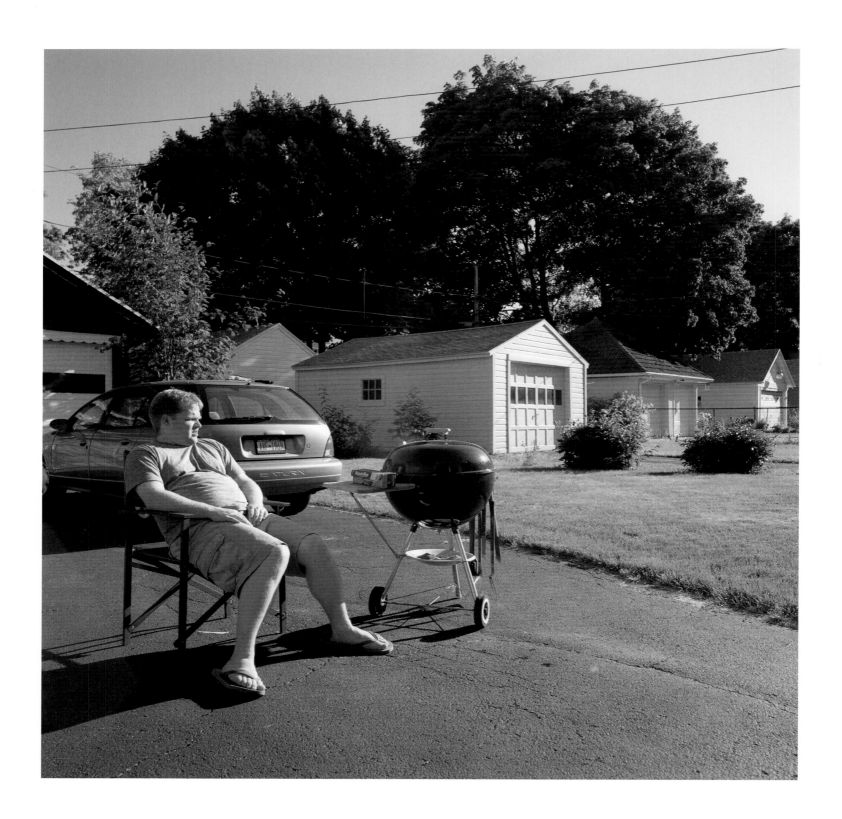

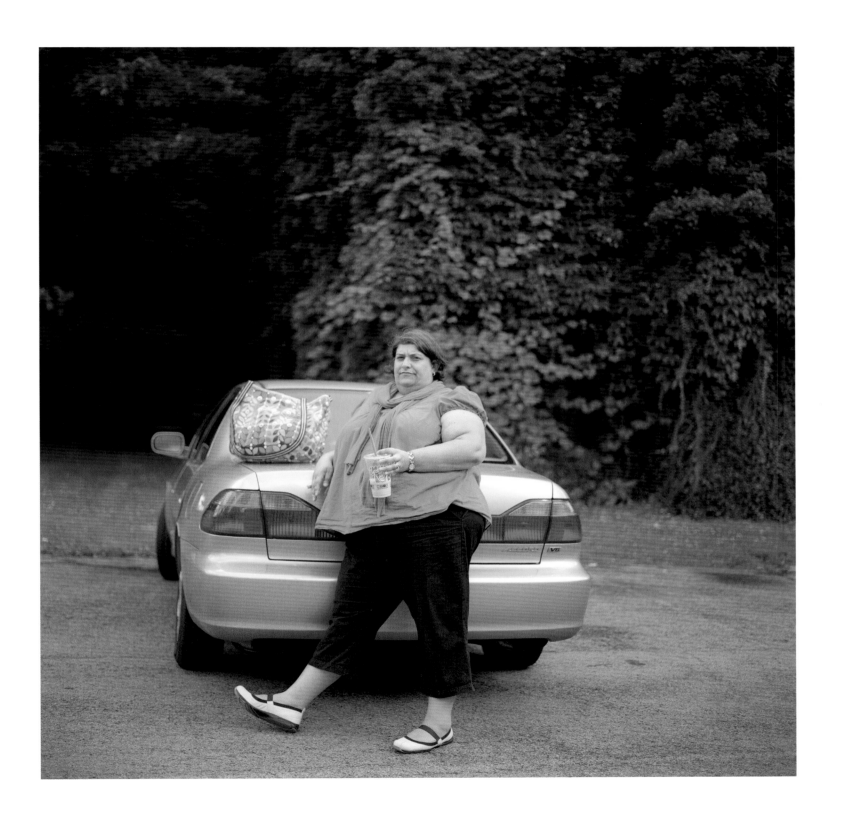

JS, Albuquerque, New Mexico (2008)

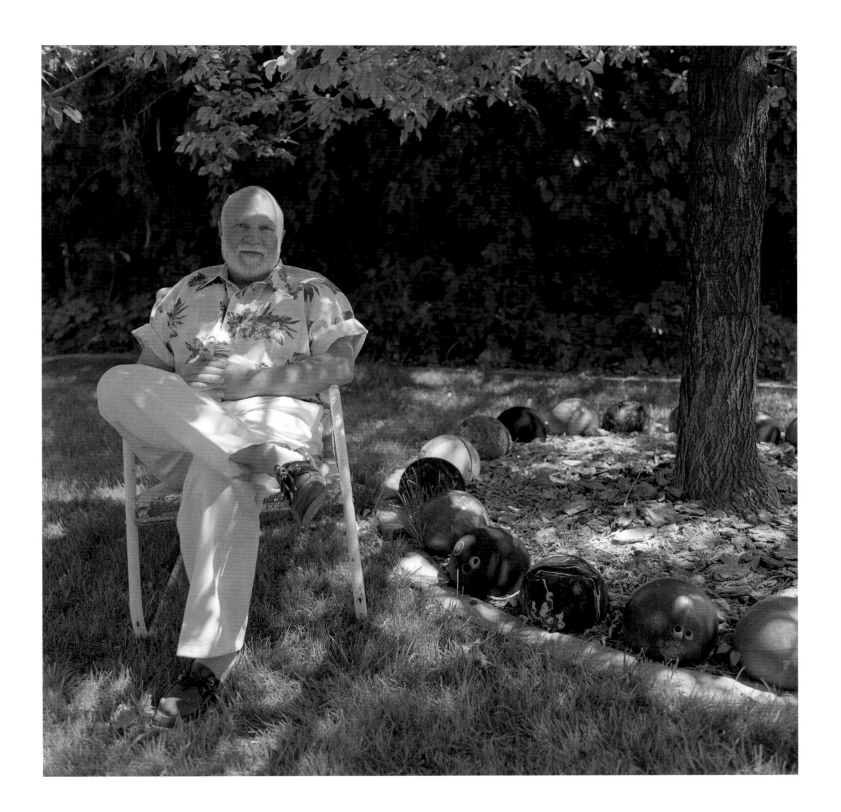

TS, Rochester, New York (2008)

RE, Brockport, New York (2008)

JE, Rochester, New York (2008)

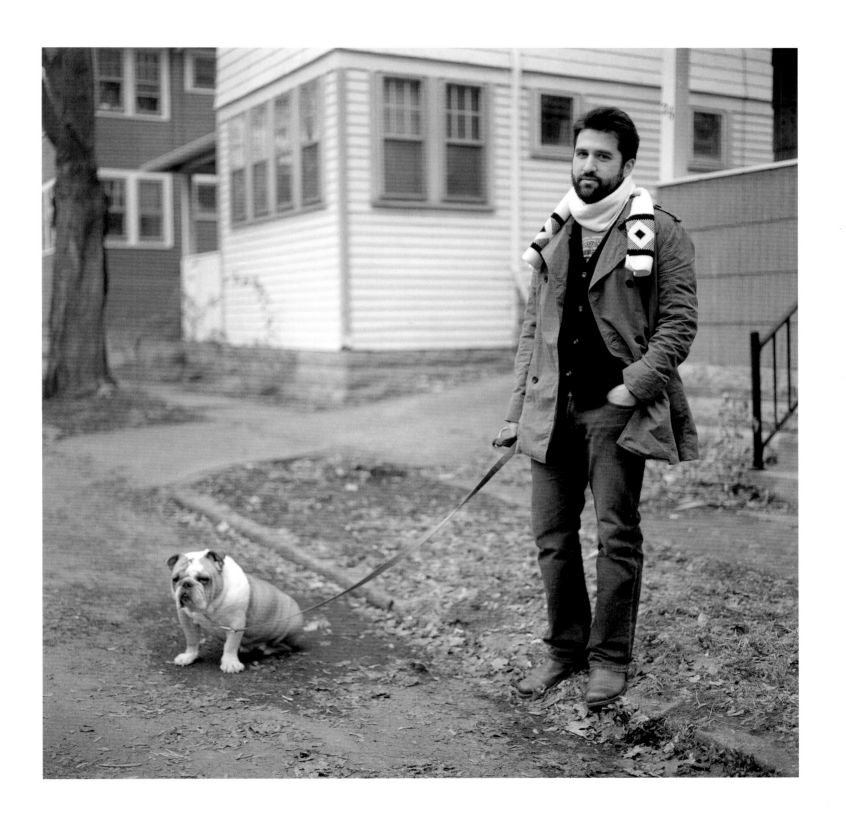

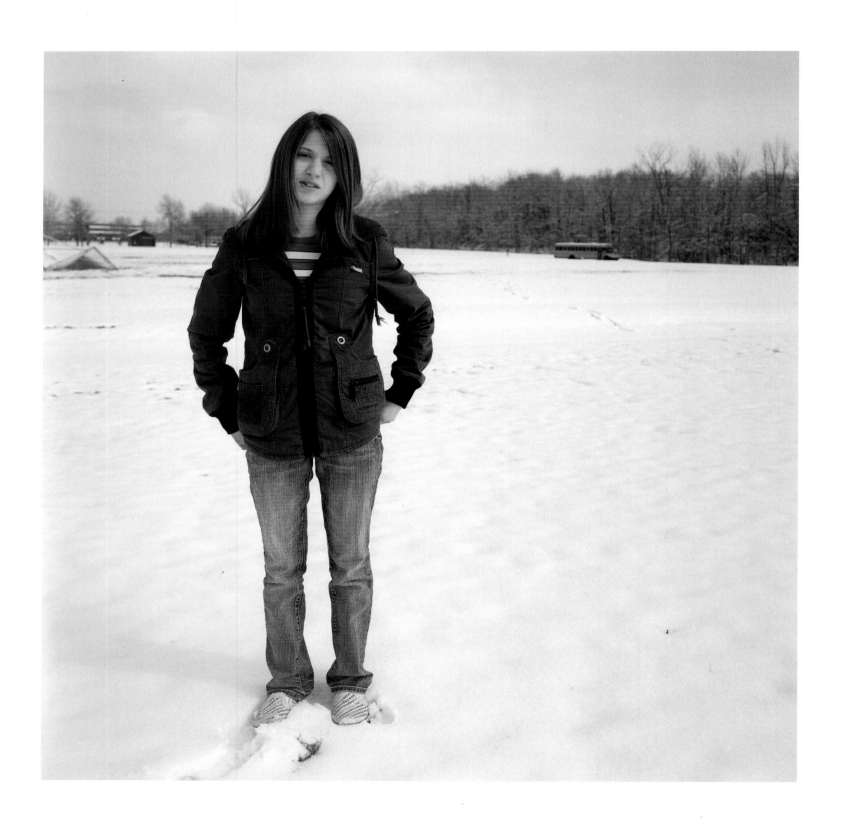

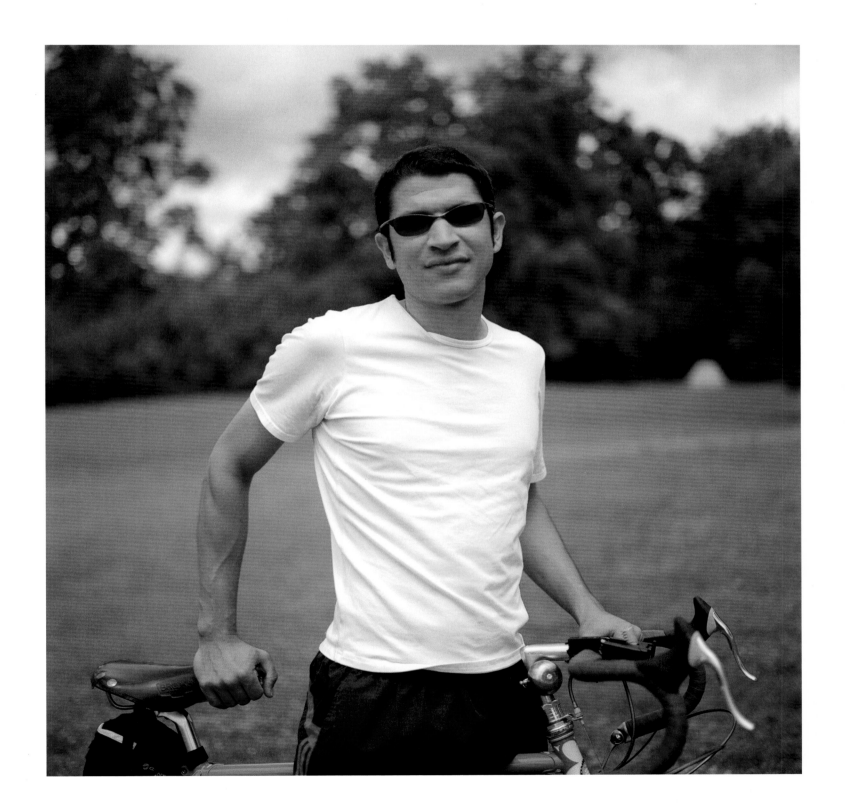

NM, New York, New York (2008)

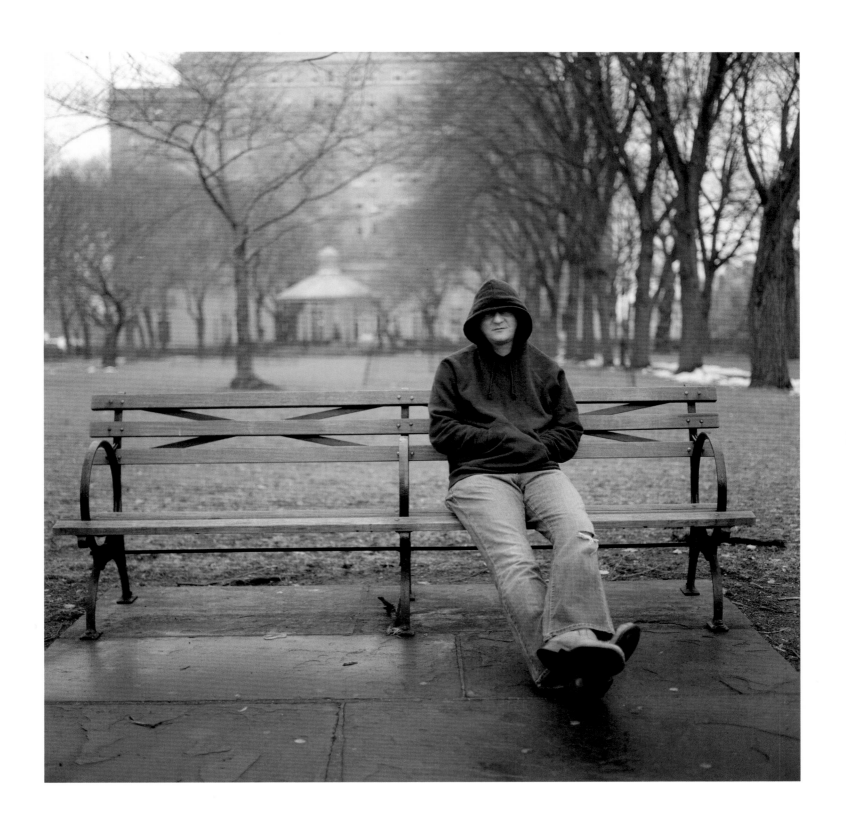

RW, Silver Spring, Maryland (2010)

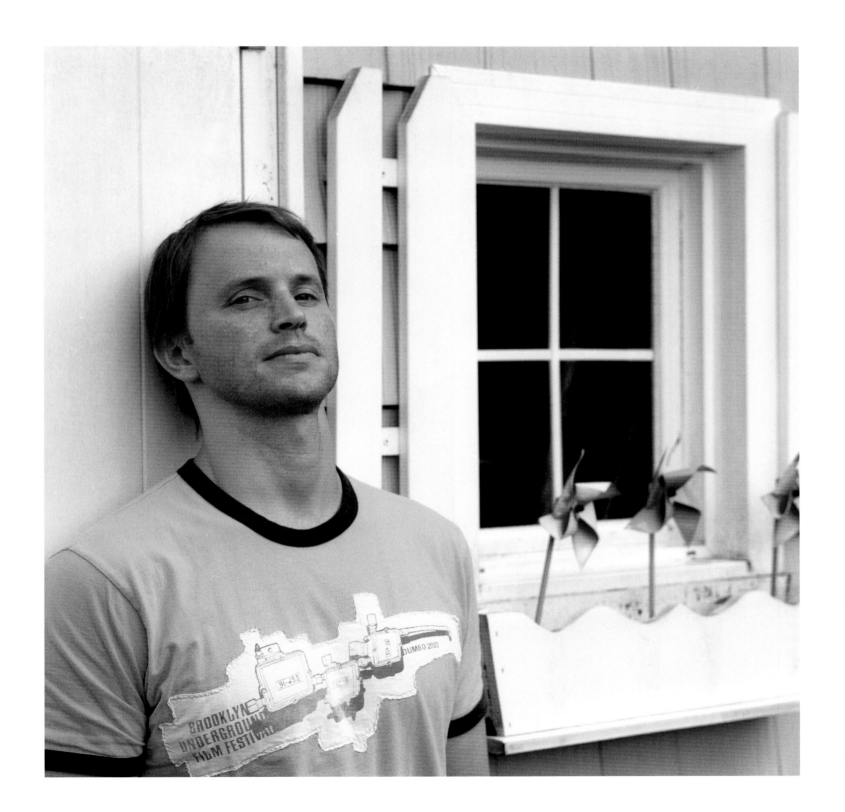

JS, Lake George, New York (2009)

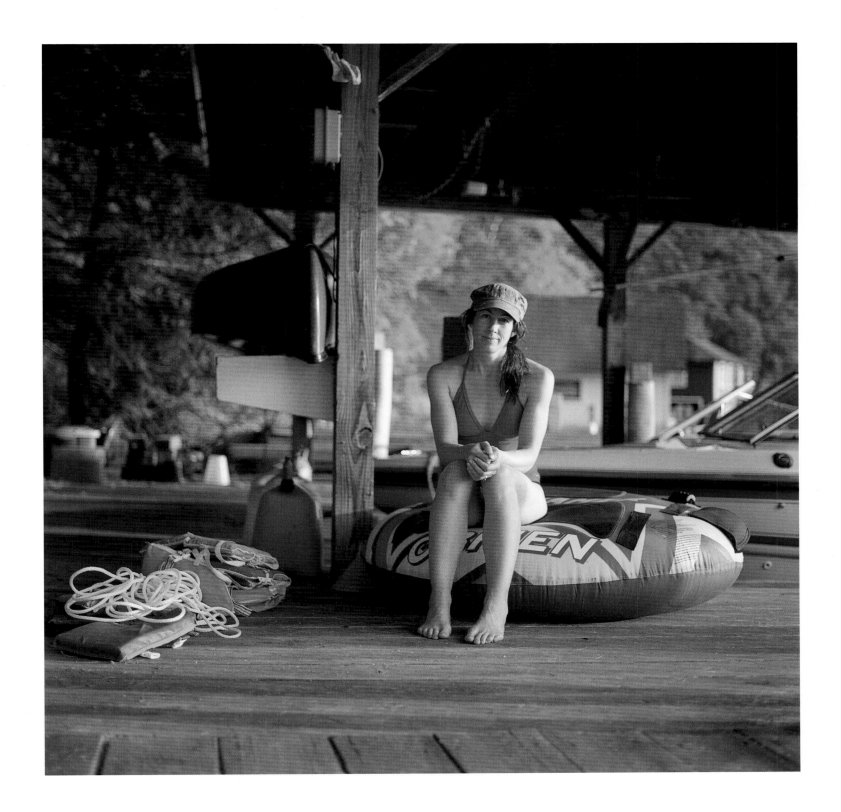

CONVERSATION STARTER with Myra Greene and Tate Shaw

TS: What was the starting point of this project? Is it one you have long thought about doing or did something specific set it in motion?

MG: In previous projects, I made a lot of self–portraits and objects that related directly to my black body. Over time I struggled with the concept of commodified blackness and how an art object helps to promote that idea. But at the same time, I was having conversations with white people about how they digested that commodification. This plays out in my project *Character Recognition*, which consists of luscious, one–of–a–kind ambrotypes on black glass that are highly aesthetic but directly confront issues of racial description.

In a late–night conversation with my friend DW in which I was perhaps overthinking the commodification of race, I simply turned to him and asked, "Do you think about whiteness in these terms?" His response was he didn't really think about whiteness. That struck me hard, and was strange, and I left that night thinking about how one could lack consciousness about one's racial identity. I had never considered this was possible. But in the end his position made absolute sense. I then started to wonder if there was a way I could use photography to both describe something many people don't actively think about, and whether whiteness could be commodified as an art object. I started making the portraits not really knowing where it would end up. I just continued making them with some faith that with more pictures and descriptive acts— some stereotypical, some "set-ups," some truths—an interesting discussion could be borne out of the pictures.

TS: Like DW, I guess I haven't thought about this enough... I guess whiteness doesn't get commodified out of guilt or because whiteness is too conservative or not "exotic" enough...?

MG: Something does not have to be exotic to be commodified. Whiteness is commodified all the time. It is the dominant part of popular culture and fed back to us as the definition of "normal." Everything else is organized around that normal. It dictates the types of characters on our sitcoms and what people we see in commercials. Our societal problem is we do not recognize that whiteness in its commodification is marketed as normal and everyday. My pictures are seen as banal or mundane because they quickly appear as something one sees everyday. But if you shift your view a bit, they call to question a lot of bigger concerns about how we describe and then think about racial identity.

TS: What kinds of things did you talk about with your friends when you were photographing them? I remember when you photographed me there was some small talk about the neighborhood I was living in then. So in part it was just something we were doing together that day as friends. I recall feeling happy to be included as a friend but also being acutely aware of myself as white, which is not something I do very often.

MG: This is funny because I photographed you three times, but you may not remember that. I do, since I am always a nervous wreck, and can remember almost every moment of imaging each person. As a friend I want to make everyone feel comfortable but as a photographer my eye is roaming trying to see the edge of a framed image, color combinations, and subtleties of detail. My brain is also trying to do exposure math.

I am a person who is very conscious of how my racial identity plays in different environments and spaces. At some point I have had either a casual or intense conversation about race with each person I photographed. I tried to talk with them in order to learn

if they are conscious of their own racial identity as they travel throughout their world. Asked to pose for racial identity portraits, some found it amusing, and you can see it caused great anxiety for others. The internal resolution of some of these issues is what the sitter brings to the picture. It may be captured in their gesture, or fabricated in their environment.

TS: Could you talk about your strategies for staging the portraits? We know the subjects to be your friends, so there is this implied expectation of an almost intimate knowledge, yet the pictures virtually teeter into the symbolic at times. I think of my own picture with my bulldog Wallace sitting there in what looks like a sad little puddle. There is an older blog I know you're aware of called *Stuff White People Like* and on the header is a bulldog, which makes your picture even funnier to me and it also makes me curious about whether you had symbols you were placing in the pictures.

MG: If I were to draw a Venn diagram, the photographs would fall in a sweet spot where stereotype, cliché, and photographic exploration all overlap. This felt like the best place to begin, trying to compose a sound picture while transforming my friends from very specific people into universal "whiteness." In doing so, there was no agenda in the act—just the longing to describe. To start, I relied on some unspoken but underlying truth in our universal American culture as a base and I drew from the shorthand comments I would use in stories to describe people or a personal experience. For instance, a story might start with me being, "the only black girl in a sports bar."

The pictures have a strange progression over time. The earlier ones are sometimes unexpected resolutions of space and ideas.

Both the sitter and me the photographer didn't really know where the picture was headed in our shooting sessions. But over time, when I saw more, and the sitters saw previous portraits, we both figured out what the dance of the picture was to be. I always try to make the expected picture and play around with something different for each person.

Environments are crucial to help support tone and potentially add to the symbolic. The place is just as large of a character as the people themselves. From the beginning, I had the project *East 100th Street* by Bruce Davidson in the back of my mind. As a teenager interested in photography and living in Harlem in the late 80s, I was told to look at those pictures (and perhaps even encouraged to make them). The often distraught, overturned, and sullen places took on a presence sometimes greater than the figure in the picture. So I learned from these pictures that environment could set the tone. And with more time I learned color and light could do the same. In all the images I try to shift and play with both the scale of the figure in the environment as well as these tones to create subtle ways the overall image speaks to whiteness.

By making this description I am sometimes subverting the sitter, who they are and their personality. Some pictures may feel unkind but in fact they serve the project and are not portraits of these people but a delicate balance describing something larger. There are some objects and places that are extremely personal for those depicted but I don't think anyone gets them except me.

TS: You traveled all over the country to make these pictures. How did that affect the project? Was it the first time you had seen the environments some of your friends currently live in?

MG: I did travel a bit to make pictures and spent the first few hours/days surveying the spaces, trying to get used to the areas where friends lived. Not knowing the places I was going created a lot of nervous thoughts. Would the light be right and available when we were there? Were the spaces visually interesting? How can I force a picture to be interesting even if the space is mundane? These are questions that keep you up at night but can't be answered until you are on–site and have your camera in hand.

TS: I think there is an interesting tension in the pictures because to me it's like you're using the rhetoric of the well–made contemporary portrait without entirely embodying that style. What do you think of the dominant portrait rhetoric? Does it exist? Is a part of the project to critique that style?

MG: Critiquing the style might be a bit of a stretch, but I am hyperaware of the strategies that other photographers employ to make pictures. But even within the realm of photographic portraiture, there is a wide variety of application and execution. I hope I have learned from them all. Rineke Dijkstra and Dawoud Bey are both accomplished portraitists, but their different styles render different responses from the viewer. Some artists are interested in the taxonomy of looking at faces, while others try to draw narratives from the body. In a way, I am interested in all of this, but also don't want to be handcuffed to the parameters of portraiture.

Before My White Friends, my work was based more in non–traditional photographic techniques and I was not necessarily concerned with real–world representation. This is the first project where my images are based in a realistic setting created by the camera. I looked at portraits to consider what was possible and tried to create my own path.

This project plays with concerns of portraiture but also sits in a realm of performance. These people are not caught in an act by the camera but instead are manicured into a space and provided an opportunity to respond to the idea of being imaged for their race. I think that is something that had the potential for a psychological effect on some sitters and they then responded to the camera and me differently. People articulated questions and concerns about if they were white enough during the shoot. Emotions vary, some offer attitude and bravado with their appearance, while others recoil and look away. All of this was recorded on the film.

TS: My White Friends has been shown publicly a few places by now including the New York Times blog, Lens. What have the responses been?

MG: The responses to the project always vary, especially if I am in the room. If I am present everyone is on their best behavior in response to the political correctness of our society. But in closed rooms, or when people don't think I am listening, the responses are different. Some are sensitive to the implications of the project, which reflect a history of America, its culture and its borders, which include and exclude people. Others find it so simple they believe it is stupid. It is the classic "I can do what Jackson Pollock did" syndrome. I don't blame people pointing out the simplicity of the project but simple questions can lead to complicated conversations and quandaries. My goal has never been to come up with definitive categories of whiteness, but instead to bring it to the forefront so we can have a shared conversation about what whiteness is and perhaps what it means. I want a conversation, not a category. And then there is a group of people who just think I am an angry black woman harping on race and waiting for

reparations. If that were true, I am not sure I would have so many friends outside my own race. Logic escapes these people.

There has been a shift in American culture I am not sure I understand. Those who want to talk about race are often called racists. It is implied that when talking about race, bad tempers will rise. This suggests we sweep all this under the table. I have been in so many conversations, talks, lectures, arguments where people state that they are colorblind. They wish America would wash itself of its racial identity. The differences are what make us all unique. Ignoring those differences or trying to assimilate them all seems to be a goal. But this is not what I want.

TS: One group that talks about race unabashedly is comedians. Why are comedians capable of talking about race in ways other commentators can't?

MG: Race has so many negative implications in society it is nearly impossible to not start a barn–burning fight around it. In the end, race is a form of description. The implications added to that description (strength, brawn, brains, sexuality, dancing abilities) are all human made. Comedians do a tricky dance, combining and separating these descriptions, stereotypes, truths, and fictions into storytelling. They are able to dissect meaning from the stereotype, and turn it on its head. Stories that make you laugh make you feel comfortable thinking of the absurd, even though the absurd is the everyday. They are able to do this not only about race, but sexuality, class, and a myriad of other topics. Richard Pryor, old Bill Cosby, Kat Williams, Chris Rock, even Louis C.K. does this around race, too.

TS: Over the past few years we have had numerous conversations about this project and I recall one particularly heated one when I suggested that someone you had photographed wasn't white—or perhaps not white enough (I don't know what racist way I put it at the time). And I believe someone told you I wasn't white but Middle Eastern. Have you experienced that reaction from others who have seen the portfolio?

MG: I am always fascinated when there is a qualifier for racial identity. If one does not qualify, they are kicked out. I am often told I am not black enough because I speak proper English. The stereotype comes from all racial sides. It fascinates me that you can be "too" something that kicks you out of a category. So if a man's nose is too broad, or his skin is not pale enough, is he then too dirty or flawed for whiteness? Is he exiled then, to be considered Puerto Rican? The question becomes where is this identity created? Is it on the surface—color of the skin—or what people read the color of the skin to mean?

My grandmother and mother and a few of my cousins are all fair–skinned black women. The fastest way to upset my grandmother is to ask her if she is Jewish. She will quickly school you about the variety of skin tones in the black American experience and end the conversation exalting that she is a proud black woman. Ironically, my cousin went to third grade a few years ago and was asked if she was Puerto Rican. I heard she gave the same speech to a scared nine year old. I guess my grandmother teaches us all the same values.

TS: I was browsing the popular nonfiction in a big chain bookstore recently and saw the title *Some of My Best Friends are Black* by Tanner Colby. On the back cover is a quote from comedic writer Baratunde Thurston, author of *How to be Black*. It says something to the affect of now it's white people's turn to take

on this uncomfortable subject so we can all move forward in the conversation because black people he felt had adequately dealt with it and could now learn from white perspectives on race in America. Do you feel the same way and is this part of the project, to start this conversation with people you know and trust?

MG: I have always contended that when we talk about race, we can not only talk about the populations on the margins. If we use race to describe, we must use it for all groups, including whites. (In some ways, this aligns with bell hooks. In her writing she asks that all races and classes be included in the movement of feminism.) This may lead us to some understanding, or maybe just more wordy descriptions. But in doing so maybe we become more mindful of how artifice and stereotype play into that act of describing.

I can't use my own body to start the conversation as I had in the past. I had to use surrogates: friends who were willing to be my models, all who went through the act of reconsidering some racial assumptions. Our conversations are ongoing and have made us more sensitive cultural citizens. Many tell me stories of how this process has shifted their perceptions, however slightly, and has caused them to think deeper about race from their own perspective. Many now know (as some knew before) that their perspective is not neutral but absolutely bound by their body. I think that is a great place to start a conversation.

TS: Do you see the book as completing the project or will it continue to evolve?

MG: The book is not a completion of the project. It's just a moment to correlate and compound all of these images and ideas together. The idea seems simple, but it is difficult to see what the statement is and how the pictures function when they are all together. After five years of shooting, re-shooting, and editing, I thought it was important to organize the pictures as a complete thought. Each image I made influenced a picture I went on to make. So I wanted to stop, take stock, and see what had culminated so far. My imagemaking has become more self-conscious the more I work on the project. I often think about what I have done: am I repeating myself, and is the repetition and the banality okay? There are a few people I still want to shoot for the project. Those images will be made and added to these.

ACKNOWLEDGEMENTS

Myra Greene was born in New York City and received her BFA from Washington University in St. Louis and her MFA in Photography from the University of New Mexico. Greene's work has been exhibited in galleries and museums nationally including The New York Public Library, the Art Museum of the Americas, Spelman College Museum of Fine Art, Museum of the African Diaspora, Yuma Art Center Museum, Wadsworth Atheneum Museum of Art, and the SculptureCenter. Her work is in the permanent collections of the Museum of Contemporary Photography, Museum of Fine Arts, Houston, The National Gallery of Art, The Nelson–Atkins Museum of Art, and The New York Public Library. She has completed residencies at Light Work and the Center for Photography at Woodstock. She currently resides in Chicago, Illinois, where she is an Associate Professor·of Photography at Columbia College Chicago.

Tate Shaw lives in Rochester, New York where he is the Director of the Visual Studies Workshop and co–publisher of Preacher's Biscuit Books. His writings on artists' books and photography have appeared in Aperture's *Photobook Review*, *Contact Sheet*, *Afterimage*, *the Journal of Artists' Books*, and *The Blue Notebook*. Shaw's artists' books are in many private and public collections internationally including the Library of the Tate Modern, Joan Flasch Artists' Book Collection at the School of the Art Institute of Chicago, and The Arthur and Matta Jaffe Collection of Modern Rare Books.

Shout out to all my friends who have stayed by my side through the years. Your support has kept me strong. My love for all of you knows no bounds.

This book was made possible with the generous support of many. Most notably John Smith, Nicole H. King, Boris Kopilenko, Nathaniel McNamara, Kimm Alfonso, Luke Feldman and Honora Dearie, Sanjiv Gajiwala, Jason and Erica Gaswirth, Arif Khan, Karina Lucero, Andrew Radin, Scott and Natalie Reinglass, Ian Van Coller, and Ian Whitmore.

Thank you Kate Bussard, Tate Shaw, John Mann, Dan Larkin, Jennifer Keats, April Wilkins, Justin Schmitz, Walker Blackwell and the staff of Latitude, Karen vanMeenen, Karen Irvine, Natasha Egan, Alexa Becker, Ariane Braun and the kind people at Kehrer Verlag. Your help, continuing support, and guidance through this process was invaluable.

Kris Merola, this book would be nothing without you. I bow down to your patience and wisdom.

Published with the generous support of the Museum of Contemporary Photography at Columbia College Chicago.

© 2012 Myra Greene, Kehrer Verlag Heidelberg Berlin

Interview: Tate Shaw, Myra Greene
Design: Kristen Merola
Image processing: Myra Greene,
Kehrer Design Heidelberg (Patrick Horn)

www.myragreene.com

Bibliographic information published by
the Deutsche Nationalbibliothek
The Deutsche Nationalbibliothek lists this publication in the Deutsche
Nationalbibliografie; detailed bibliographic data are available in the
Internet at http://dnb.d-nb.de.

Printed in Germany

ISBN 978-3-86828-322-8

Kehrer Heidelberg Berlin
www.kehrerverlag.com